·THE·ANATOMY·OF·LETTERS·

THE ANATOMY OF LETTERS

a guide to the art of calligraphy by

CHARLES PEARCE

TAPLINGER PUBLISHING COMPANY, INC.

New York

First Printing
Published in 1987 by Taplinger Publishing Co., Inc.
New York, New York

Copyright 1986 by Charles Pearce
All rights reserved
Published in the United States of America

Library of Congress Cataloguing-in-Publication Data

Pearce, Charles.
 The anatomy of letters.

 Bibliography: p.
 1. Calligraphy. I. Title.
Z43.P372 1986 745.6'1 86-5740
ISBN 0-8008-0199-7 (pbk.)

For Mark, Aaron, Daniel and Aaron.

CONTENTS

ACKNOWLEDGMENTS

I wish to thank Louis Strick, who was the initial impetus behind this book and who was also its editor, and Michael Gullick, who read through the manuscript and made a number of salient observations.

Secondly, I want to thank my tutors, because much of what is in this book is information which they passed on to me: Donald Jackson, for his informed criticism and encouragement over the last twenty-five years; Eric Flegg, who first put a broad-edged pen in my hand; Dorothy Mahoney, Ann Camp, and William Gardner who were my tutors in the last full year of calligraphy at the Central School of Arts and Crafts, London; David Dewey and last, but not least, Sidney Bendall. I must also acknowledge the written works of: Donald Anderson, Heather Child, Edward Johnston, E. A. Lowe, and Joyce Irene Whalley, which have been major sources of information for me.

Introduction

There is a danger inherent in calligraphy which is probably not present in any other art form. That danger is the assumption that because we all write in varying degrees of beauty and legibility we only have to make our writing more formal to become calligraphers. Would that it were that simple.

Although the word "calligraphy" comes from two Greek words, "kallos," meaning beautiful, and "graphos," meaning writing, it is very much more complicated than that. While calligraphy, like all the fine and graphic arts can be broken down ultimately into just two shapes—the straight line and the curve—the calligrapher has more discipline imposed upon him not only by the twenty-six basic, familiar shapes, but also by their preordained arrangement.

In this book we will try to explain some of the intricacies of what has become an increasingly complex art form, first by tracing the history of the alphabet as we know it. And then by the use of a revolutionary new technique in the exemplars or copy sheets of the various alphabets. Instead of ink the letters are formed by a chisel-edged marker which shows the overlays of the strokes or the organic quality of the calligraphy and how the strokes grow one from another. This marker technique gives the book it's title, *The Anatomy of Letters*. Finally we shall end with the ways in which these letters may be put together to create a fine piece of finished work.

During the course of history the role of the scribe has slowly changed from being, at first, that of a communicator to creator of beautiful books, then with the invention of moveable type an office clerk or scrivener (and occasionally a writing master) to finally, after the invention of the typewriter a creative and decorative artist. It is also worth mentioning that many of the lasting typefaces have been designed by people who first learned letters by writing them with a broad-edged pen, thus coming to understand the nuances and subtleties which go into the design of beautiful letter forms.

A great deal has been said and written over recent years about the freedom and spontaneity which is required in calligraphy. These are certainly admirable qualities in any writing, but the first and most important prerequisite for a calligrapher is strong letter form. Letter forms are the building blocks of calligraphy, and without strength they will only bring weakness to a written piece. Once those strengths have been recognized and acquired, freedom and spontaneity will come with familiarity and use.

Arguments have also abounded recently as to whether the writing in ancient manuscripts was formed by holding the pen at a constant angle, or by manipulation, or even by use of pressure at strategic times on a more flexible pen. Suffice it to say that probably a mixture of all three is closest to the truth. It must be realized that the tools used in medieval times and before were quite different from those of today. It is much easier, for example, to manipulate an inflexible steel pen to achieve a thickening at the beginning and ending of the stroke, than it is to do so by exerting pressure which is perfectly feasible with the much more flexible reed or quill. Perhaps those who argue for only one way as being correct should try spending more time using different tools and materials.

In spite of what some teachers, books, and manufacturers of "calligraphic items" may tell you, there is no quick and easy way to become a calligrapher, any more than there is of becoming a concert pianist. Hokusai, the famous Japanese printmaker, was reputed to have been most distressed over his impending death in his middle nineties, because he felt that he was just beginning to understand what his art entailed. Calligraphy is no different in that it will always produce new challenges even to the most experienced practitioners. We must all aim for perfection while understanding that we can never achieve it. Not to aspire toward it, however, is to cheat ourselves.

As artists, we are all makers of marks and it is what we do with those marks that makes us good, bad or just indifferent. In the final analysis we are all trying to make pleasing form and texture from our lines.

History

In his book *Politics and Script*, Stanley Morison states that, because our alphabet began in Roman times we have no need to go further back to understand its development. This rather blinkered view negates the fifteen hundred to two thousand years of collective effort that went before that final shape. Our knowledge and understanding of the history of writing can give us insight into, not only the "soul" of a style of lettering, but also a distinct feeling for the period itself.

Up to the middle of the second millennium B.C. there were three main areas where some form of written communication flourished. These were the Nile valley, the area between the Tigris and the Euphrates known as the Fertile Crescent, and the Far East. The Egyptian civilization of the Nile valley had developed a form of writing known as hieroglyphics, a pictographic writing in which each symbol represents a whole word. Later this developed into the hieratic script and its simplified form the demotic script. In Mesopotamia, the early Sumerians had developed a form of writing which could be impressed into a clay tablet with a stylus and this is known as cuneiform. This method was later passed on to the Babylonians and Assyrians.

Sometime around 1600 to 1500 B.C. the alphabet foreshadowing our own appeared. Now, instead of having to use one symbol for one word, syllable, or sound, it became possible to convey that word, syllable, or sound by the juxtaposing of letters. The original Semitic alphabet was a series of symbols, each of which had a distinct meaning. Our letter *A*, for instance, the Semitic aleph, was originally the head of a bull which became inverted. The top part was the head, and the two feet, the horns. The Semitic alphabet gradually came to be adopted by the Phoenicians and, as they began to wield more influence in the Mediterranean through their trading empire, so the new writing became more widely known.

Although the Semitic alphabet made rapid progress in historical terms, the island of Crete, home of the Minoan civilization, had seen the introduction of a script of sorts as early as 3000 B.C. this system was fully developed by about 2000 B.C. and was then superseded some 200 years later by another alphabet. The end of the Minoan civilization in about 1100 B.C. meant that the Minoan writing system was lost to the world until its rediscovery at the beginning of the twentieth century.

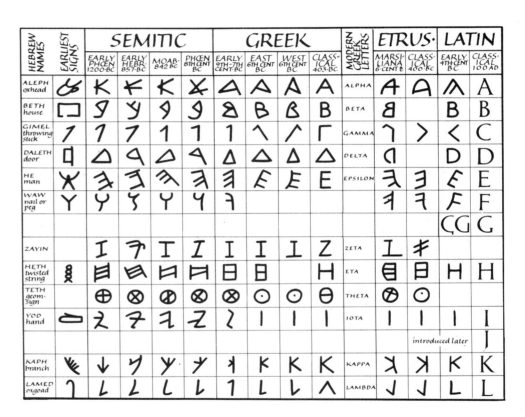

Chart showing the development of the alphabet from the early Signary up to the classical Roman letters

										(Greek name)				(Latin)
MEM water										MU				M N
NUN snake										NU				N
SAMEKH fish										XI				
AYIN eye										OMICRON				O
PE mouth										PI				P
SADHE snare ?														
QOPH monkey														Q
RESH human head										RHO				R
SHIN mtn. peak										SIGMA				S
TAW mark or brand										TAU				T
										UPSILON				V
										introduced later				U
										CHI				X
														Y
														Z
				PHI	PSI	OMEGA	DIGAMMA			introduced later				W

5

As the early Greek civilization gradually came to the fore. The old Phoenician trading outposts on the mainland of Greece gave the Greeks a ready made alphabet and although the symbols did not always represent the same sound, it was a fairly simple task to adapt the symbols to fit the Greek sound values.

By about 300 B.C. Roman writing, as we know it, and inscriptional lettering, were both fully developed, and from that time on to this day, most of the changes have been changes of style more than anything else. A few letters have been added at different times, but by and large, we are still writing with the letters which evolved nearly twenty five centuries ago. How much the Romans took directly from the Greeks, or how much from their neighbors the Etruscans who had been influenced by the Greeks, is open to question. Certainly, the same letters can be found in both alphabets. *J U* and *W* were added through the centuries. Others have been injected into the alphabet from time to time, but they have since dropped out. One of them, "thorn," was the letter which signified the sound "th" and had the look of a compressed capital *Y*. It can still be seen today in some signs such as Ye Olde Gifte Shoppe, where it is mispronounced as a letter *Y*.

While the Romans were not notably inventive in the development of a writing system they were certainly responsible for its attaining a much higher standard of craftsmanship. Perhaps the most important gift of the Romans to the makers of letters was their system of proportions which, while intended for incised letters, still governs the making of capital letters to this day.

In the middle period of the Roman Empire there were two distinct styles of lettering in use. The Monumental Roman capitals and Rustic capitals. When written they are known as "capitalis quadrata" and "capitalis rustica." From the calligraphic point of view, the quadrata would be considered to be the more formal of the two.

As the Roman Empire spread outward from Rome, its system of communication and its culture also spread. Throughout many parts of Europe, Asia Minor, and North Africa the ruins of their buildings as well as their fine inscriptions can be seen. The inscription generally considered to be the finest by lettering people is the one on the base of the Trajan Column in Rome itself. Many treatises have been written about these beautifully formed letters and their influence on modern letter forms. The serious student is urged to study them.

At about the time of the official adoption of Christianity in Rome there was an abrupt change in the style of writing to

Capitalis quadratus from a book of Virgil

Capitalis rustica in the Codex Palatinas

7

what is now called the Roman uncial. When the Christian proselytizers went out from Rome to convert the heathen they took this new hand with them. Monasteries were established and most of these monasteries had scriptoria where books could be produced for the Church. After one of these missionaries, St. Augustine of Canterbury, arrived in England the English evolved their own style of uncial—a considerably more graceful version of the earlier Roman letters. The English uncial is exemplified in the Codex Amiatinus.

Toward the end of the so-called Dark Ages new centers of learning sprang up. One of the first was the Irish monastery, St. Columbo, on the Island of Iona a few miles off the coast of Scotland. Many of Europe's most skillful artists and scribes lived and worked at Iona for all learning and, indeed, all books and art were centered in the Church at that time. It is now thought that the book of Kells and the book of Durrow may well have been executed at Iona. The Lindisfarne Gospels while written at another Irish monastery on an island close to the

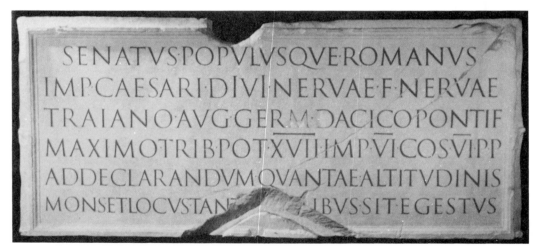

Cast of the Trajan inscription prepared by Edward Catich for R. R. Donnelley & Sons

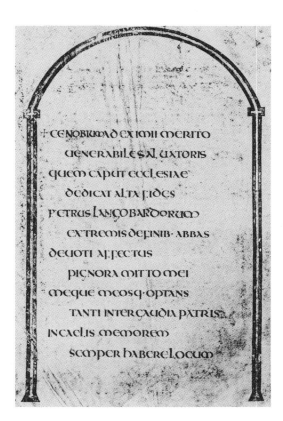

CENOBIRMAD EXIMII MERITO
UENERABILES AI UXTORIS
quem caput ecclesiae
dedicat alta fides
petrus langobardorum
extremis definib· abbas
deuoti affectus
pignora mitto mei
meque meosq·optans
tanti inter gaudia patris
in caelis memorem
semper habere locum

Dedicatory verse from the Codex Amiatinus

coast of Northumberland bears many resemblances to the Ionian writing style—the hand which we now call the half-uncial. This style is a rather complicated hand to write as it requires a certain amount of pen manipulation. Even more than that, it needs the flexibility of a quill to give the pressure variations which can be seen in the letters.

While the more formal books were written in the half-uncial hands a cursive hand was also used for less formal texts. Although written into the Lindisfarne Gospels some two hundred years after its completion, the tenth-century Anglo-Saxon interlinear gloss is a fine example of this hand. Throughout the rest of Europe, following the fall of the Roman Empire, the standards of writing went into a rapid decline. In the year 771 A.D., the Emperor Charlemagne established his Holy Roman Empire. Charlemagne felt strongly that it was essential to have a uniform system of writing so people could learn to read and write. He called upon Alcuin of York to organize a team to design an alphabet to be used throughout the Empire. Taking as their model the hand in use at the monastery of St. Martin at Tours, the team of scribes developed the hand which is now known as Carolingian.

England fell under the sway of the prevailing writing style of western Europe. After the demise of the Holy Roman Empire, the hand is thought by many to have reached its apogee at the

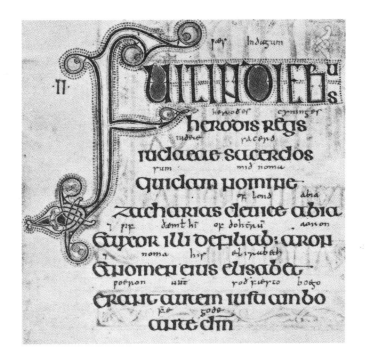

The Lindisfarne Gospels with a later Anglo-Saxon gloss

scriptorium at Winchester in England, in the tenth century. It was this Winchester hand which Edward Johnston took as his model for the Foundational hand. The particular manuscript which he used was the Ramsey Psalter (British Library, Harley 2903.)

A new style was beginning to sweep across Europe. The Gothic influence was to be felt in all facets of the decorative arts and in none more so than calligraphy. After the pleasantly rounded letters of the Holy Roman Empire, the letters of the new style were tall and angular. Many more words could be fitted onto a single page than at any time previously; a great advantage since all writing was on expensive vellum or parchment in the pre-paper era.

For the first time since the end of the Roman Empire learning was no longer the sole prerogative of the Church. A new class had sprung up, the merchant class, and the sons of these merchants had the money for a secular education. Thus, this became the period noted for the establishment of many of the great European universities. The students needed books and the fewer the pages, the cheaper the book. The compact Gothic script or Black Letter helped keep book prices down. The quantity of books required led directly to a new industry, commercial book production which operated under the guild system.

The Ramsey Psalter in the tenth-century Winchester hand

The Bedford Hours and Psalter, written A.D. 1420–22 in the London workshop of Herman Scheere for John, Duke of Bedford

Despite the growth of the new writing style, one or two pockets of Europe were scarcely affected by the Gothic influence, notably the City States which make up present-day Italy and Spain. The closest that these Latin countries came to a Gothic hand was the handsome rounded letter known as Rotunda. This alphabet came into prominence late in the Gothic period and just before the birth of the Italian Renaissance. It was widely used throughout southern Europe and formed the basis of a number of typefaces following the introduction of moveable type.

The Renaissance was probably the single most important explosion of learning in history. This nostalgic retrospection brought about something new in all facets of the arts, and not least of all in calligraphy. The study of old manuscripts and the appreciation of their calligraphy suggested to the scribes the styles that they might adopt. Basing their thinking partly on the Carolingian hand and partly on the Roman inscriptional letters and manuscripts, the Italian calligraphers began to develop a style which was a slightly more formal version of the Carolingian added to the classical Roman quadrata capitals. One scribe who was particularly influential in this development was Poggio Bracciolini. Poggio, as he is generally known, traveled all over Europe looking at manuscripts in his search for texts that would serve as suitable models for his new hand.

He apparently traveled as far as England where he is reputed to have been able to see only one manuscript. Perhaps it is fanciful to think that the one manuscript he saw was the Ramsey Psalter (the one which influenced Johnston so much). Certainly, the "corsiva humanista" (humanist cursive), which became the writing hand of the time, reflects certain of the characteristics of that tenth-century Winchester hand.

As time passed and speed in writing became more and more important, cursive qualities began to creep into the letters and they lost some of their formality. Letters developed a slight slant, some had ligatures connecting them, and, eventually, a completely new style came into being—Italic ("corsiva cancellaresca," so called because it was adopted as the official hand of the Vatican scribes.) The two hands—humanista and cancellaresca—were used side by side for many years and were often used together in the same manuscript.

All of this evolution in writing style, however, is considered by many to be just the prelude to one of mankind's greatest inventions—moveable type. The art of printing spread rapidly across the whole of Europe, and while, for a short time, the patrons of the scribes considered the printed book to be a cheap alternative to the real thing (manuscript books continued to be produced in some number up until early in the sixteenth century), it was not too long before the scribe found himself

Italian Epistle Book, A.D. 1368, in Rotunda

Humanist Italic hand *ca.* A.D. 1543

almost an anachronism. Calligraphers, from this time on, would be forced to find other outlets for their skills, such as the inscribing of official documents, but these opportunities were rather few and far between and gave employment to a very small number of people.

Many of the better scribes coming onto the scene at about the time of the introduction of printing turned the new invention to their advantage and produced writing manuals which showed their skills to even wider audiences. While at first the books were reproduced from wood blocks and the writing masters carefully oversaw the printing it was not long before it was seen that metal plate would produce a sharper image. The calligrapher's original was handed over to the engraver and with it went his control over its quality. These engravers were extremely skilled craftsmen in their own right, but they were not scribes. They did not understand the subtleties and nuances of the letter executed with a broad-edged pen. The plates were engraved with a burin (the engraver's tool, also known as a graver) and the strokes were made thicker and thinner by the amount of pressure exerted. Before long, it was obvious that a flexible, pointed quill (later a steel pen) could more easily and faithfully reproduce the letters which characterized the engraver's art. From this time on, the standard of writing started to decline and any understanding of what could be achieved with a broad-edged pen was lost.

By the beginning of the seventeenth century the northern scribes were wielding more influence than their Italian counterparts. It seemed as though anyone who had pretensions to the teaching of writing was publishing his own copybook and this led to a further decline in standards.

One or two penmen, such as Edward Cocker in England, were their own engravers, and because of this, the attitude to writing began to change. The penman started to emulate the engraver, which in itself, often presented great difficulties. Writing is a free-flowing art dependent upon a single stroke of the pen. The engraving process, on the other hand, is fairly slow and requires the movement of the plate beneath the burin, rather than the other way around. Whereas the graver can often reproduce what the pen has done because its slower speed makes possible greater control, it is infinitely more difficult for the pen to reproduce the work of the graver. The original written flourishes on some of the early seventeenth century works were not nearly so perfect as the finished engraved piece would lead us to believe.

Such was the state of writing at the start of the eighteenth century that it can be said unequivocally, that calligraphy was

dead. What was being taught was handwriting, a practical subject, and not the fine art that calligraphy had once been.

And so, by the beginning of the nineteenth century, the writing arts which had had such a glorious past, seemed, at last, to have been laid to rest, the letter forms of the Renaissance, calligraphy's summit, had become so debased as to be almost unrecognizable. While attempts were made to set up writing programs, notably the Palmer method in America, the lack of knowledge and understanding of the roots of the letters doomed such efforts to failure at least from an aesthetic point of view.

With the latter part of the nineteenth century, however, came a new renaissance, particularly in Great Britain, in the form of a reaction to the Industrial Revolution and its mass production techniques. The arts and crafts movement, of which William Morris was a leader, brought with it a new awareness of design values in many different fields, but in textiles and printing especially. Through his love of printing, Morris had become interested in both calligraphy and illumination and had tried his hand at both. Not surprisingly, however, he had been unable to fathom the concept of the broad-edged pen and all of his letters had been built up. Edward Johnston, a not particularly robust medical student, saw some of Morris's work and became very interested. With the encouragement of W. R. Lethaby, then principal of London's Central School of Arts and Crafts, he abandoned his medical education and began to study the wealth of manuscripts in the British Museum.

Fairly early in his researches, Johnston came to the conclusion that the writing in those early manuscripts had been done with a broad-edged rather than a pointed pen. Through careful experimentation he taught himself to cut quills and to prepare vellum and parchment for writing. His special field of study was the half uncial hand, but he was drawn more and more to the tenth-century Winchester hand in the Ramsey Psalter. From it, he developed his first real teaching hand, the Foundational, still considered, because of its rounded and open feeling, to be one of the best for the beginning calligrapher.

In 1899, Edward Johnston began to teach his first class at the Central School. Nominally a class in illumination, it proved to be an education for both students and teacher alike, experimenting, as they were, with so many newly rediscovered ideas. Johnston's researches and experience in teaching led him to publish his first book in 1906. This book, *Writing and Illuminating and Lettering* is still looked upon as the calligrapher's "bible." Although a wonderful source of information, it

is a little difficult for the beginning student, with its numerous cross references. Despite this, it will stand forever as the first complete, and many ways the best, how-to-do-it calligraphy manual ever written.

At about the same time that Johnston was doing his researches into letter forms in Britain, similar interest was being shown in the lettering arts in Europe. The Austrian, Rudolf von Larisch, was the archivist of the order of the Toison d'Or and keeper of the Hapsburg records. As such, he had access to a great many historical manuscripts and his comparisons of those with the debased writing of his own time so disgusted him that he was moved to write numerous articles in an attempt to make other people aware of how low standards had fallen. Following the publication of his pamphlet, "Zierschriften im Dienst der Kunst," he was appointed to the Vienna School of Art in 1902 as lecturer in Lettering.

Most prominent among German calligraphers of that era was Rudolf Koch, an inspirational teacher, scribe, and type designer. He had a great feeling for calligraphy, and especially for the way it should be allied to type and type design. He also felt that most questions and problems in the graphic arts field were to be found and could be solved in the design and execution of a manuscript book. Although he died in 1934 his students and assistants have carried his thoughts and ideas through to the present day, and many of today's most important developments in calligraphy and type design, especially in the United States, can be traced to Koch's influence.

In Britain, although Johnston's interest had been primarily in the tradition of the medieval manuscript, it was not exclusively so. In 1916, London Transport commissioned him to design a type face for its exclusive use. His sans serif face, based on the classical proportions of the monumental Roman capitals, is still in use today, and is the forerunner of many of the sans serif faces used at present.

In 1921, a number of Johnston's students got together to form the Society of Scribes and Illuminators, an organisation dedicated to promoting active interest and discussion in the calligraphic art. From the time of its inception to the present day, it has seen design gimmicks come and go, but it has always remained faithful to the Johnstonian ideals. Lay membership of the Society is open to all who have an interest in the lettering arts.

In recent years many new and exciting things have been happening in the calligraphic field. Young designers from other professions have crossed over and brought with them different approaches to problems, thereby encouraging many other

calligraphers to break out of the somewhat restrictive bounds laid down by the more traditional approaches to calligraphy. Not all of this experimental work has been successful, but then the very word experiment suggests failure as well as success. Most of the English-speaking world is now experiencing an extraordinary upsurge in interest in calligraphy. The boom which began in North America with the formation of the various calligraphic societies following Donald Jackson's first workshops in America has spread worldwide. There have been a number of annual conventions of calligraphers meeting in a different city each year, attracting students and teachers from all over the world. These symposiums and the societies which organize them promote further workshops, lectures, exhibitions, and discussions that further help to raise the standards of calligraphy and lettering.

All of the research and effort that has gone into the revival of calligraphy as an art during this century must prevent it from ever falling into complete disuse again. It is up to us to ensure its continued growth and progress. As was said in the London *Times Literary Supplement* back in 1965, "The art of calligraphy has been twice killed stone dead by a mechanical invention and has twice found a new set of justifications. As an industry for the manual copying of texts it was destroyed by the printing press. As an essential tool of commerce and finance, and an evidence of gentility, it flourished for three centuries and was strangled by the typewriter. In its third and present lifetime it stands with the fine arts, safe from any further technological threat."

We devoutly hope so.

Tools and Materials

The ideal work space for the calligrapher, as with any other artist, is a room which he can call his own, far from any noise or other distraction. It should also be well lit, but above all the user must feel totally at home in it for it is impossible to produce good work while feeling uncomfortable. If a separate room is not available, then use the corner of a room which is away from the general traffic. If there is a carpet on the floor, either remove it or protect it with a sheet of plastic. Anyone can spill a bottle of ink.

When working under natural light, the right-hander should place the table so that the light comes directly from the left. Then the hand won't cast a shadow over the writing area. Naturally, if the student is left-handed, the reverse is true. Throughout history, artists have been told that they should work under natural rather than artificial light, and that preferably it should come from the north so there are no harsh shadows. This is because electric light has a different color temperature from natural light and can alter the apparent hues of the work. However, the necessity for working under natural light is not nearly so important these days as it was earlier, because now most museums, galleries, and other show spaces are artificially illuminated.

At least two sources of electric light would be considered ideal—the first being general room lighting from overhead and the second, task lighting such as a desk lamp which may be adjusted to the most advantageous position. Fluorescent lighting, while inexpensive to run, is not recommended for studio lighting. It flickers at the same rate as the current alternates and while this is virtually undetectable by the optic nerves it does place a great strain on the eyes and even has a soporific effect if used for any length of time. Always try to work under incandescent light.

Worktable and Seating

Although, of all of the arts and crafts, calligraphy can be done with the smallest amount of expenditure on tools and materials, careful selection of a chair and work desk are of paramount importance. Again, it is essential to be comfortable to be able to work well. The ideal chair is of the swivel type, that has a seat which can be adjusted up and down, as well as a

back which can be moved forwards and backwards. If at all possible, find a chair of this type which has no casters. This will ensure that there is no sudden unexpected backward movement (a rather disconcerting occurrence when writing.) The chair should also be armless to allow plenty of freedom of movement.

If money allows, the purchase of a drafting table, complete with a parallel motion, will pay handsome dividends at a later date. The height can be raised and lowered, the angle altered and the work surface can be swivelled, all very easily, which is highly efficient. The parallel motion makes ruling-up pages a much simpler operation. Should there be a choice, select a parallel motion where the cables are fixed to the underside of the board and which has a steel edge rather than plastic. It will be indestructible and can even be used as a straight-edge for cutting, something which certainly should not be done with a plastic edge.

If a drafting table is out of the question, then an ordinary drawing board will suffice (the board should measure at least 15″ × 22″.) This board may either rest in the lap against the edge of the table, or it may be hinged to the table with a convenient amount of overlap, and then a block of wood should be placed underneath to raise it to the required angle. The wood block can be moved backwards or forwards to lower

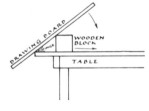

Hinge the drawing board to the table as shown. Lower the angle by moving the wood block away and vice versa.

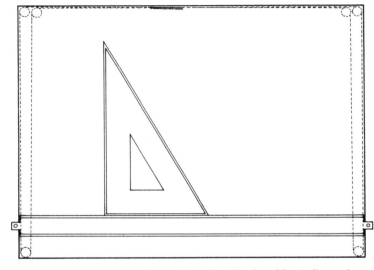

Drawing table equipped with parallel motion. The dotted line indicates the position of the cable and pulleys attached to the rear of the board. The cable crosses over itself at the top where a spring also keeps the correct tension.

or raise the board angle. Many books will tell us that the correct angle for writing is this, that or the other, but the fact of the matter is, that there is no "correct" angle. We all write in slightly different positions because we are all built differently,

so sit and write in the position and with the board at the angle which happens to feel comfortable.

While it is possible to fit a parallel motion to an ordinary drawing board, it is not particularly recommended. Instead, use

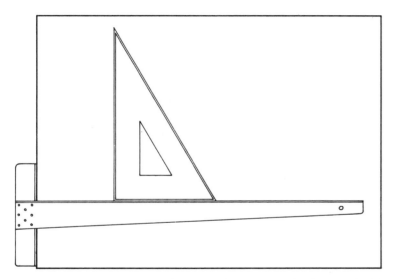

Drawing board using T-square and triangle. Select a T-square that has a good solid joint at the T, it will stay square longer. If a wooden T-square is chosen, it should have an ebony edge.

a T-square, which can be moved up and down the left-hand edge of the board. For drawing vertical lines, do not reposition the T-square, but lay a triangle set square on the board, butted up to the T-square and draw the verticals with that. No drawing board is ever guaranteed to be square, but triangles are.

Tools to Write With

It has been said that one should be able to write with anything on anything, within reason. While this may be reasonably accurate, the calligrapher limits himself to a pen of some description, usually broad-edged, and pencils to rule lines (although a stylus may be better, particularly on vellum.) The calligrapher can make a quill or a reed pen or he may buy a steel dip pen.

Edward Johnston considered the preparation of the writing tools and materials to be just as much a part of the art of calligraphy as the writing itself. There can be no doubt that cutting a quill or reed (see Donald Jackson's *The Story of Writing* pp. 56–57) and the preparation of vellum can be very satisfying and everyone reading this is urged to try it at some time or other. However, it is not essential in gaining a good hand.

There are a number of good steel pens available at most art stores which will work well once they have been broken in. Fountain pens may also be used but only as training tools. They should not be used for finished calligraphy (more of that later). All steel broad-edged pens come in two pieces—the nib and the reservoir. Some of these pens are already assembled and others are not. Generally speaking, the reservoir is mounted on the top of the pen. The Mitchell Round Hand pen, on the other hand, comes with a separate reservoir which is then mounted underneath the point. For larger writing there are the Automatic lettering pens and the Coit pens as well as a number of others. It is a good idea to try as many different kinds of pens as possible to find the ones which suit you, which flow well with different kinds of ink, and which also write sharply with crisp definition and contrast between thick and thin strokes.

There are always a number of inks on the market purporting to be "calligraphy ink," nearly all of them somewhat suspect. Inks fall into two distinct categories and can be bought at most art stores or stationery shops. One type is made from aniline dye. This group includes most of the inks which are sold as fountain pen inks as well as a number of so-called "calligraphy inks." While these may be acceptable for practice and will work very well in fountain pens, they are not designed for finished work. Having no body, they will look washed out and also, being fugitive, will tend to fade in strong light.

The other type of ink is made from a pigment such as lamp black, a form of carbon. All of these pigmented inks have a tendency to settle and should be stirred or shaken before use. Pigmented inks also clog fountain pens which is why fountain pens cannot be used for finished work. Included in this group are the India inks which should NEVER be used by calligraphers unless they are specifically labeled NON-waterproof. The waterproof constituent in India ink is shellac and there is also a flow agent to keep the shellac from drying in the pen or the brush. This flow agent unfortunately makes the ink spread when it comes in contact with the paper and it is impossible to achieve a thin line. Beware of any inks labeled "free flowing" for it will be difficult, if not impossible, to execute a hairline. In bottled pigmented inks neither Higgins Eternal or Pelikan Fount India have flow agents and can be used. Professional calligraphers often use Chinese stick ink. This is purchased as a stick and is rubbed down with a small quantity of water on an ink stone. Only enough for immediate use is made as it deteriorates if it is kept over.

Part of being a calligrapher is having to rule lines. Some of the more free and expressive work will not require them, but

for the most part they will be necessary. All lines must be kept as light and fine as possible and must be accurately drawn. Use either a very sharp, medium hard pencil, or alternatively a continuous lead pencil The latter come in a variety of lead thicknesses and it is not necessary to sharpen the point of the 0.3mm lead.

Materials to Write On

There are two basic materials which calligraphers work on—paper and animal skin. Other materials are sometimes used such as silk, canvas, glass, and plexiglas, for instance, but general use of these media is still a long way off.

Paper can be divided into three distinct categories: handmade, mould made, and machine made. The best papers are those which are handmade and these are generally used for better quality work. Handmade paper is still made much as it was in the Orient many centuries ago. A frame, which holds a wire mesh, is dipped into a vat containing a pulp usually made from cotton (sometimes linen) rags and water. The water drains off through the mesh and the resulting sheet is laid on a felt mat and is pressed to remove much of the remaining water. It is then allowed to dry. Mould made paper is manufactured in a similar fashion, but semi-automated so that the frames, instead of being hand held, are mounted on a revolving drum which picks up the pulp and then deposits it on a mat. Machine made paper is the product of a fully automated system whereby the pulp (often made of wood, sometimes cotton or a combination of the two) is picked up in a continuous process and made into rolls of paper which are later cut into sheets.

The finishes on all the three types of paper may be either wove, a very slightly textured, almost smooth paper, where the mesh is constructed from evenly spaced wires running in both directions, or laid, a more obvious texture, from a mesh made with very tight horizontal strands but very open vertical ones. The surfaces on handmade and mould made papers come as hot pressed (a fairly smooth finish, ideal for calligraphy), and cold pressed (a rougher surface more suited to watercolor, although some may be smooth enough to be used for calligraphy.) Although handmade papers are generally considered best for calligraphy, some mould made papers also make excellent writing papers. Machine made papers come in a myriad of different types of colors, many of which are suitable for roughs and for work which will be used for reproduction. In this category, look for a layout bond that is both smooth and has a good tooth (when writing, a slight drag will be felt as

the pen is pulled across the paper.) If the paper is too slick, the pen will be more difficult to control.

Animal skins are not widely available and, as might be expected, are considerably more expensive. They are also the supreme writing material. They generally fall into two distinct groups—vellum and parchment. Vellum is the whole, untanned skin of a calf and, ideally, is from a new-born animal. Today's animal husbandry is such that the fine skins used by the scribes of a thousand years ago are not available to us. Vellum may be bought in one of two ways—it is either prepared on both sides (sometimes called Manuscript Vellum) so that it may be used in a book, or prepared on one side only, Classic, for use as an illuminated address, or proclamation, etc. Once purchased the skin will still need further preparation. To begin with, it must be carefully sanded with a fine sandpaper or "wet and dry" until it raises a very slight nap. It is then treated with powdered sandarac or pounce (a combination of sandarac, powdered pumice, and whiting) to produce the perfect writing surface.

Parchment is the untanned skin of a sheep which has been split to make it thinner and easier to handle, after which it is prepared in much the same way as vellum. Because it is rather greasy, it is much less satisfactory to work on than vellum and it is now usually used for the printing of important documents. Whichever skin is employed, a quill, or a reed pen for larger writing, should be used.

Although calligraphy is one of the few crafts which can be undertaken without significant expense, nevertheless the student should make things as easy as possible for himself. This is a craft which requires considerable discipline, and poor and shoddy tools and materials will only lead to discouragement. It is worth spending that little extra to obtain a better product. The idea that the student should begin with cheap pens, ink, and paper makes little sense. It should almost be the reverse: that one starts with the best and, after gaining some skill, works with materials of lesser quality.

Starting to Write

To begin with, make sure that all of the tools which you will require are close at hand. Having to get up to find things while you are working is not conducive to acquiring a good rhythmical hand. Sit comfortably without slouching and without crossing your legs—this only interferes with blood circulation. Some people find that a small footstool is useful when having to sit at a drawing-board for any length of time.

Once you have made all of these preparations, you should start by drawing all of the writing lines as shown on the exemplar sheets which follow. Take a small piece of paper and draw out the pen widths as indicated. These must be drawn by pulling the pen across the paper in a horizontal direction. The dimensions made by these pen widths should then be carefully marked off on the page of writing paper. Remember, different pen size—different pen widths. Tape the writing paper to the drawing board with low tack masking tape and then, using a sharp pencil and a T-square or parallel motion, rule the lines accurately and faintly. Accuracy is essential, because any

variation in the x-height will be obvious once the writing is complete. As you gain experience and your eye becomes trained you will write with only the bottom line.

After the lines have been ruled, remove the paper from the board and place it in such a way that the calligraphy can be done in a small area directly in front of you. Try to position your head so that your line of sight is at the right angle to the point where you are writing. The angle from which you will be viewing the writing will be constantly changing and there is a good chance that the same thing will happen to your calligraphy. For this reason, you should move the paper along so that you can write in that same small area all the time.

When they come from the manufacturer pen nibs are normally coated with a thin layer of lacquer and if this is not removed it can interfere with the flow of ink. Removing the lacquer can be done in two ways. For the first, hold the pen point over a flame for a few seconds (after it has been inserted into a penholder) and then plunge it into cold water. This method has the added advantage of tempering the steel of the pen. For the second, dip it into a solution of ammonia and water for a short while then rinse the pen out thoroughly afterwards.

Check the pen to make sure that the tines of the point are

Draw the pen widths on a small piece of paper and then mark them off on the writing area.

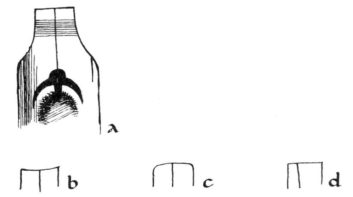

a. A good penpoint will have sharp, true corners, a flat blade, and generally good punching.

Some of the more common faults are:

b. The blade is "cupped," the corners of the pen touch the paper but not the split that carries the ink so that the flow is interrupted.

c. The corners are rounded which means that the width of the line drawn will not have full value, and will also have slightly ragged edges.

d. The split is not in the center, which means that the rest of the stamping will also be out of square. Ink flow will be poor.

not being pushed apart by the pressure exerted by the reservoir. This tends to happen more with Mitchell pens than others because the pressure comes from the underside of the pen rather than from on top. If the tines of the nib are slightly apart, ease the tip of the reservoir away with a fingernail until daylight can no longer be seen between them. It is important that the tip of the reservoir touches the pen or the ink will not flow properly. If the tines of the point will not close, the nib will have to be discarded and a new one selected. Incidentally, when buying pen points, you should check them very carefully to make sure that there are no irregularities on the blade of the pen. These irregularities can consist of: rounded corners, split not in the center, rough edge to the blade, generally poor punching, etc., and they can all interfere with the successful flow of ink and subsequent fine writing. If you are not entirely happy with the look of a pen point for any reason, do not buy it. It will probably not work well.

Before starting to write letters, it is a good idea to familiarize yourself with the way that the broad-edged pen creates thick and thin strokes. To this end, a short series of exercises has been included. Remember that throughout all of these practice pieces the angle of the pen remains constant.

Generally speaking, letters are started on the thin strokes as the ink flows to the blade of the pen from the reservoir along

the split between the tines. Thus, when the letter is begun on the thin stroke, the ink is immediately distributed along the blade of the pen which makes a clean start. If begun on the thick stroke of the letter, the ink is not evenly spread over the blade of the pen, the ink flow is often interrupted and it is difficult to achieve a sharp, crisp line.

It should be noted here that all of the letters in the following exemplar sheets were written with a chisel edged marker and then reproduced so that the overlapping of the strokes (their anatomy) can clearly be seen. The smaller gray letters indicate the direction and order of the strokes. Although the sample alphabets begin with the Foundational hand, the remainder

follow in their historical chronological order. In each case, the alphabet should be run through a few times until a certain familiarity with it has been achieved. Having done that, try writing a few words and then some sentences as rhythmically as possible. Note from the double page spread immediately following each sample hand, that the space between letters, words and lines differs depending on the style of writing used. The more space there is inside the letters, the more space will be required between them. The ductus on each sampler sheet is intended to give a running commentary on the alphabet, indicating the various points that should be observed in that particular hand.

(*left*) The ink is distributed to the blade of the pen from the reservoir by means of the split between the tines of the nib; (*right*) By starting the letter on the thin stroke, the ink is immediately and evenly distributed along the blade of the pen.

EXEMPLARS

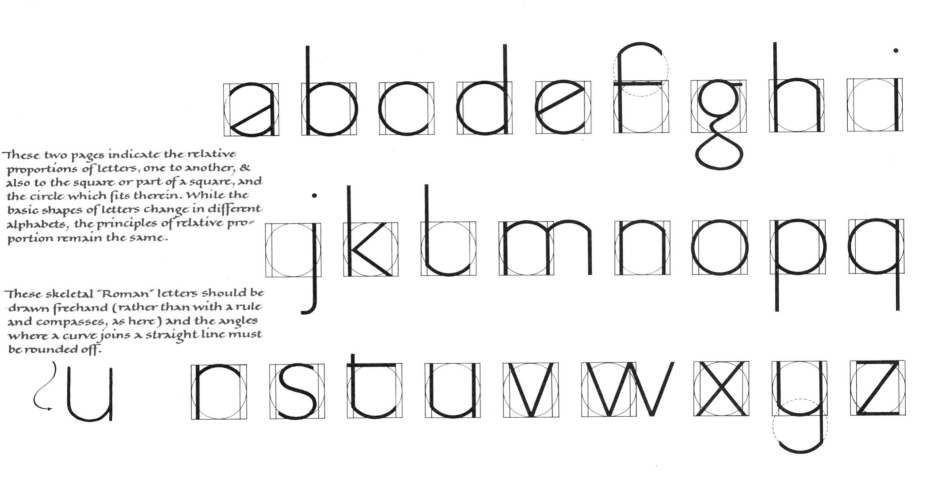

These two pages indicate the relative proportions of letters, one to another, & also to the square or part of a square, and the circle which fits therein. While the basic shapes of letters change in different alphabets, the principles of relative proportion remain the same.

These skeletal "Roman" letters should be drawn freehand (rather than with a rule and compasses, as here) and the angles where a curve joins a straight line must be rounded off.

LETTERS BASED ON A CIRCLE

C D G O Q

WIDE LETTERS

M W

The proportions of these letters are based on the Monumental Roman Capitals such as can be found on the inscription of the Trajan column.

HALF WIDTH LETTERS

B E F K P R S I J

NARROW LETTERS

RECTANGULAR LETTERS

A

Notice that the "halfway" point on the letters A, B, E, F, H, K, P, R, S & X does not fall on the center line. It is placed either slightly above or below to help give a letter its correct center of gravity.

H N T U V X Y Z

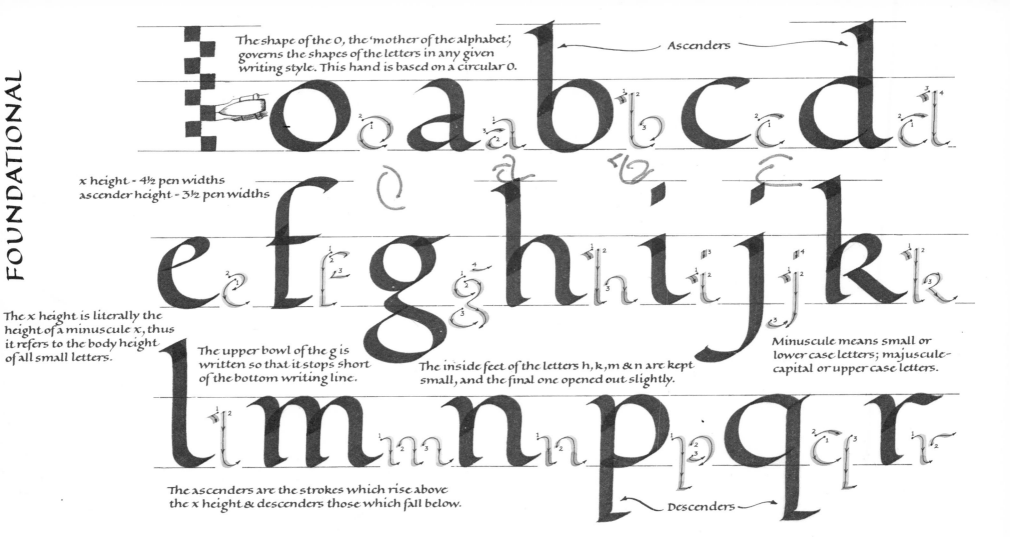

FOUNDATIONAL

The shape of the O, the 'mother of the alphabet', governs the shapes of the letters in any given writing style. This hand is based on a circular O.

Ascenders

x height = 4½ pen widths
ascender height = 3½ pen widths

The x height is literally the height of a minuscule x, thus it refers to the body height of all small letters.

The upper bowl of the g is written so that it stops short of the bottom writing line.

The inside feet of the letters h, k, m & n are kept small, and the final one opened out slightly.

Minuscule means small or lower case letters; majuscule capital or upper case letters.

The ascenders are the strokes which rise above the x height & descenders those which fall below.

Descenders

s t u v w &

The w should be like
two v's joined together.

The thickening of the stroke at the top of the
ascender is called the serif, and is formed in
two strokes.

The space between letters is called the 'interspace';
the space inside the letter – the 'counter'.

x y z 1 2 3 4

The dots, arrows and numbers on the broken-down
pale grey letters indicate the starting point, direction
and order of the strokes respectively.

Writing height is governed
by the size of pen used.
This is why we talk about
writing height in pen
widths. Make pen widths
by pulling the pen hori-
zontally across the page
and not vertically.

5 6 7 8 9 0

The 'up & down' effect of the numerals
is traditional but not essential.

Pen angle about 35°.

O o A a B b C c

Capital height = 6 pen widths

Capital letters are written two pen widths shorter
than the height of the minuscule ascenders.

D d E e F f G g H h I i

The pen angle on the vertical strokes of the N
may be steepened slightly to lighten their weight.

J j K k L l M m N n

These capital letters are
based on Monumental
Roman Capitals. Try to
keep to these strong and
simple proportions.

The tail of the J should be
rather small & discreet.

P Q R S T

Because these are written with
the pen at an angle of less than 45°,
the vertical stroke will be thicker
than the horizontal. This is im-
portant because the eye reads the
vertical parts of the letters more
than the rest. By emphasizing
the verticals slightly, confusion
in the reader will be avoided.

In the W strokes 1 and 3 are
parallel to each other as are 2 and 4.

U V W X Y

Study both the main letter and the breakdown
so that the whole letter may be written without hesitation.

& Z $ ¢ £

Pen angle about 35°.

I i IN THE BEGINNING GOD created the heaven
and the earth.

ii And the earth was without form, and void; and
darkness was upon the face of the deep. And the
Spirit of God moved upon the face of the waters.

iii And God said, Let there be light: and there was
light.

iv And God saw the light, that it was good: and
God divided the light from the darkness.

And God called the light Day, and the darkness v
he called Night. And the evening and the morn=
ing were the first day.

And God said, Let there be a firmament in the vi
midst of the waters, and let it divide the waters
from the waters.

And God made the firmament, and divided the vii
waters which were under the firmament from
the waters which were above the firmament: &

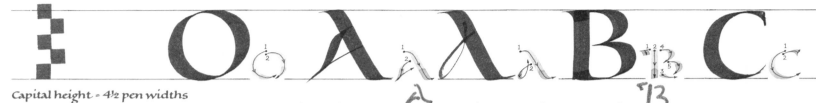

Capital height = 4½ pen widths

This particular Uncial hand requires a certain amount of pen manipulation and tricks. The pen angle has a tendency to vary throughout, but the main angle is almost flat.

The tops of the c, the first e and both g's are formed by allowing the pen's right hand corner to lift up while the left corner carries on through and below.

The little 'hooks' on the top of the ascenders on the h, k and l, as well as the p, are not essential and may be left off.

Because these letters were written with a felt marker to show the anatomy of each letter, certain extra strokes had to be added to reproduce the hand accurately. If a quill had been used, simple pressure would have thickened the ends of the strokes.

M m N n P p q q R r

The thin strokes on the n and also the second a were written
by turning the pen onto its left corner. Apart from the bottom
stroke on the s, it is always the left corner which is used.

S s T t U u V v W w X x

Uncials are NOT capitals for Half-Uncials
& should be kept separate.

Y y G g Z z

This Uncial hand is loosely based on a version of Uncials in use in
England in the 8th Century. This hand is fairly typical of the style
written in the scriptorium at Canterbury.
(see the Psalterium Romanus cum canticis in the British Library.)

Pen angle about 10°.

IT WAS SO·

viii AND GOD CALLED THE FIRMAMENT HEA-
VEN· AND THE EVENING AND THE MORNING
WERE THE SECOND DAY

ix AND GOD SAID· LET THE WATERS UNDER
THE HEAVEN BE GATHERED TOGETHER UN-
TO ONE PLACE· AND LET THE DRY LAND
APPEAR: AND IT WAS SO·

x AND GOD CALLED THE DRY LAND EARTH;

AND THE GATHERING TOGETHER OF THE
WATERS CALLED HE SEAS: AND GOD SAW
THAT IT WAS GOOD.
AND GOD SAID, LET THE EARTH BRING xi
FORTH GRASS, THE HERB YIELDING SEED,
AND THE FRUIT TREE YIELDING FRUIT
AFTER HIS KIND, WHOSE SEED IS IN IT-
SELF, UPON THE EARTH: AND IT WAS SO.
AND THE EARTH BROUGHT FORTH GRASS, xii

o a b c d

x height = 4½ pen widths
ascender height = 1½ pen widths

Almost a complete circle should
be made before the down stroke is
added to the a.

All the classical Half-Uncial letterforms are shown here but
a number are included which were designed to make for a
more modern version of the alphabet.

d e f f g

In the original manuscripts the thickening at the
bottom of the vertical stroke would have been achieved
by exerting pressure on the quill.

h i j k l m

N H P Q R

In the classical Latin manuscripts the letters j, k, v, & w do not exist, and y & z were only used for proper names.

N·B· The letters f, m, modern n, p & r, all start slightly below the top x height line.

S T U V W

While most of these letters are written with the pen angle almost flat, that angle is varied at times. This is particularly evident in the v. Careful study will show other variations.

X Y G Z

These letters are taken from examples which can be found in the Book of Kells and the Lindisfarne Gospels. It is probable that the style originated at Iona, a small island off the coast of Scotland, which was one of the great cultural centers of Europe in the 7th & 8th Centuries.

Pen angle about 10°.

and herb yielding seed after his
kind, and the tree yielding fruit,
whose seed was in itself, after his
kind: and God saw that it was good.
xiii And the evening and the morning
were the third day.
xiv And God said, let there be lights in
the firmament of the heaven to

divide the day from the night; and
let them be for signs, and for sea-
sons, and for days, and years:
And let them be for lights in the *xv*
firmament of the heaven to give
light upon the earth: and it was so.
And God made two great lights; the *xvi*
greater light to rule the day, and

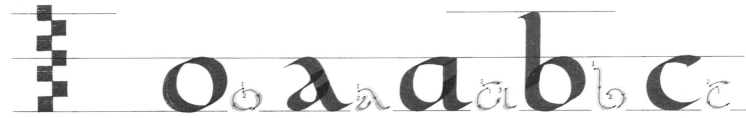

x height - 3½ pen widths
ascender height - 3 pen widths

While looking somewhat similar to the Foundational hand, this alphabet is one full pen width shorter than it and is thus much squatter in appearance.

Note the different shapes in the top and bottom bowls of the g.

This is one of the most practical of present day hands. Because it is written quickly it can have great rhythm and also good legibility.

p q r s t u v

This hand has many letters which are written in one
stroke in a similar way to the Italic. This makes for
greater speed and fluidity.

w x y z 1 2 3 4

The tail of the 'y' is written with the
pen held on its left hand corner.

The numerals do not have to be 'up and
down', but this is traditional.

5 6 7 8 9 0

The 'Running Book Hand' is based
on the same style of writing as the
Foundational Hand – Carolingian.
However, Edward Johnston used
the 10th Century Winchester hand
as the basis for his Foundational
alphabet, whereas this one follows
earlier French models.

Pen angle 35° to 40°

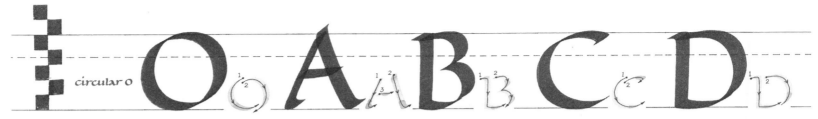

circular O

Capital height = 5 pen widths

Note how the bottoms of the letters such as B, D, E, F and L are slightly rounded. This lends a slightly informal feeling to the characters.

E E F F G G H I

These letters may also be used as small capitals in an Italic hand. Small capitals are the same height as the x height of the rest of the copy.

There is almost no manipulation of the pen in this hand. The only exception being the N, where the pen angle is steepened slightly on the vertical strokes to reduce their weight.

J J K L M N

P P Q R R S S T T U U

It is important when writing a line of
capitals to ensure that they are adequately spaced.

These capitals, again, are based on the
Roman monumental letters, but they
are a little squatter.

U U V V W W X X Y Y Z Z

Observe how the central stroke of the W curves
over itself. This kind of subtlety is what gives
this hand a lot of character.

A variety of some letters has been included
to offer more or less formality as required.

& & $ $ c c £ £ ! ! ? ?

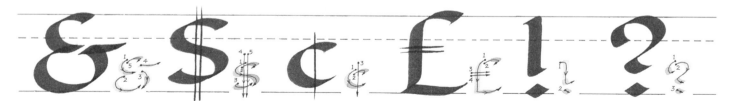

Pen angle 35° to 40°

the lesser light to rule the night: he made the stars also.

xvii And God set them in the firmament of the heaven to give light upon the earth,

xviii And to rule over the day and over the night, and to divide the light from the darkness: and God saw that it was good.

xix And the evening and the morning were the fourth day.

xx And God said, Let the waters bring forth abundantly the moving creature that hath life, and fowl that may

fly above the earth in the open firmament of heaven.

And God created great whales, and every living crea= xxi
ture that moveth, which the waters brought forth
abundantly, after their kind, and every winged fowl
after his kind: and God saw that it was good.

And God blessed them, saying, Be fruitful, & multiply, xxii
and fill the waters in the seas, and let fowl multiply
in the earth.

And the evening and the morning were the fifth day. xxiii
AND GOD SAID, LET THE EARTH BRING forth xxiv
the living creature after his kind, cattle, and creeping

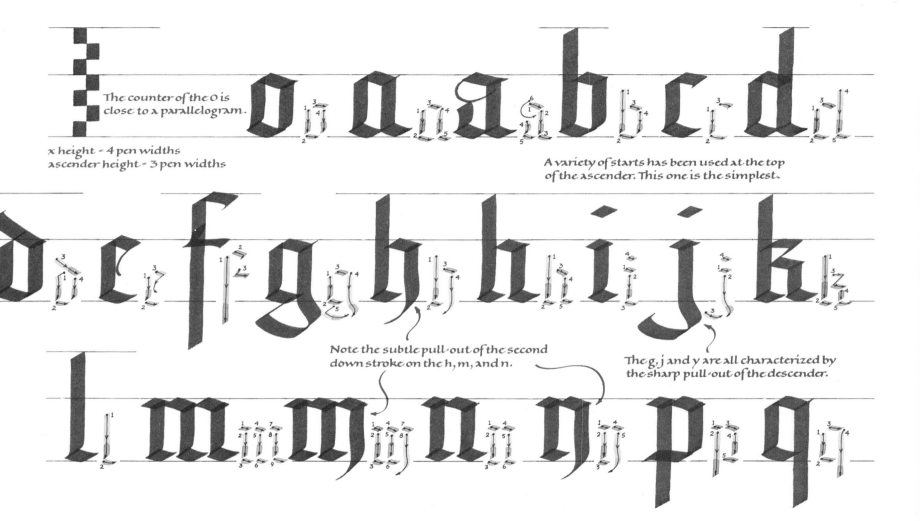

GOTHIC BLACK LETTER

The counter of the O is close to a parallelogram.

x height = 4 pen widths
ascender height = 3 pen widths

A variety of starts has been used at the top of the ascender. This one is the simplest.

Note the subtle pull-out of the second down stroke on the h, m, and n.

The g, j and y are all characterized by the sharp pull-out of the descender.

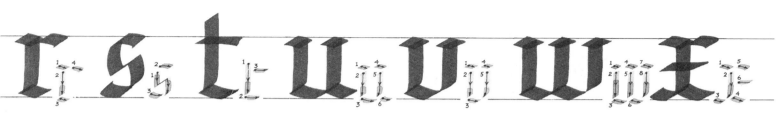

r s t u v w x

The reason for crossing the x and z is to
keep the solid texture of the writing. A white
patch would show without the crossing stroke.

Other letter constructions will be observed in old
mss. particularly the 2 (r) and the archaic ſ (s).

y z & 1 2 3 4

These numerals are very much doctored versions.
There were no Arabic numerals in use in Western
calligraphy when the Gothic hands were popular.

5 6 7 8 9 0

This Gothic hand is based on an
alphabet in use at Winchester at
the beginning of the 15th Century.
It does have a tendency to be taller
than the classic Gothic Black
Letter.

Pen angle about 35°

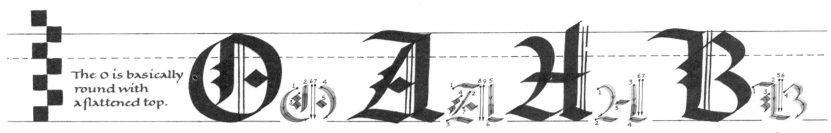

The O is basically round with a flattened top.

Capital height - 5½ pen widths

Gothic capitals, because of their basic illegibility, should only be used with minuscule letters, in text; they will appear very awkward on their own.

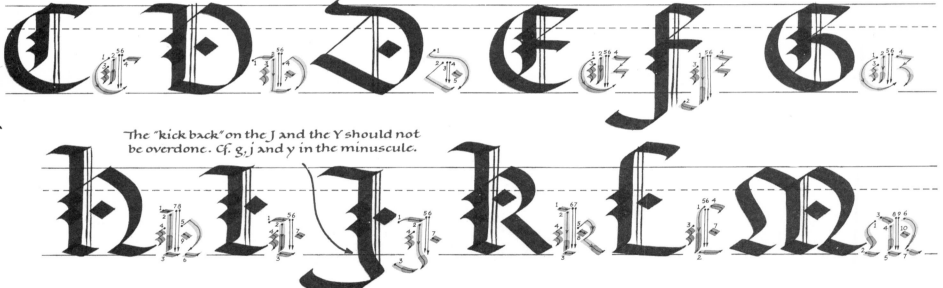

The "kick back" on the J and the Y should not be overdone. Cf. g, j and y in the minuscule.

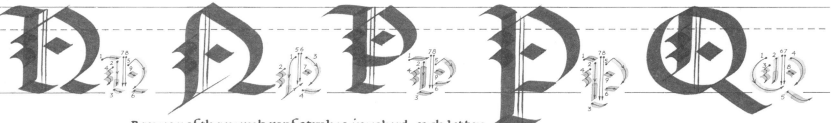

Because of the number of strokes involved, each letter will be slow to write, tending to interfere with the rhythm.

The Z is crossed to give the whole letter more substance. It would look thin without it.

These capitals are based on the 'in text' letters such as would have been found in 14th & 15th Century mss. For the most part, capitals used to start verses and chapters would have been Versal Letters.

Pen angle about 35°.

thing, and beast of the earth after his kind: and it was so.

xxv And God made the beast of the earth after his kind, and cattle after their kind, and every thing that creepeth upon the earth after his kind: and God saw that it was good.

xxvi And God said, Let us make man in our image, after our likeness: and let them have dominion over the fish of the sea, and over the fowl of the air, and over the cattle, and over all the earth, and over every creeping thing that creepeth upon the earth.

xxvii So God created man in his own image, in the image of God created he him; male and female created he them.

And God blessed them, and God said unto them, Be fruitful, **xxviii**
and multiply, and replenish the earth, and subdue it: and have
dominion over the fish of the sea, and over the fowl of the air,
and over every living thing that moveth upon the earth.

And God said, Behold, I have given you every herb bearing **xxix**
seed, which is upon the face of all the earth, and every tree, in
the which is the fruit of a tree yielding seed; to you it shall be
for meat.

And to every beast of the earth, and to every fowl of the air, **xxx**
and to every thing that creepeth upon the earth, wherein
there is life, I have given every green herb for meat: and it

The O is based on a softer, rounded parallelogram.

o o a a a a b b c c

x height = 4½ pen widths
ascender height = 2 pen widths

d d o o e e f f g g g g h h

The flat bottoms on the strokes of the f, h, k, m and n, etc. are executed with the left hand corner of the pen & filled in as necessary.

The tops of the ascenders are formed by starting the stroke with the pen at almost 0°, and then changing the angle during the stroke to about 30°.

i i j j k k l l m m n n

p q r 2 s ſ f

When the rest of Western Europe was heavily involved in the strongly vertical feeling of the Gothic Black Letter, the Rotunda hand became the alphabet of choice in Mediterranean countries. This reflected the general attitudes of Latin peoples to all things.

The archaic 2 (r) and ſ (s) have been included for reference purposes, but will not be required in normal English usage.

t u v v u w w

The whole of the Rotunda hand is a softer and slightly fuller letter than the Gothic Black Letter.

x y y z &

Pen angle about 35°.

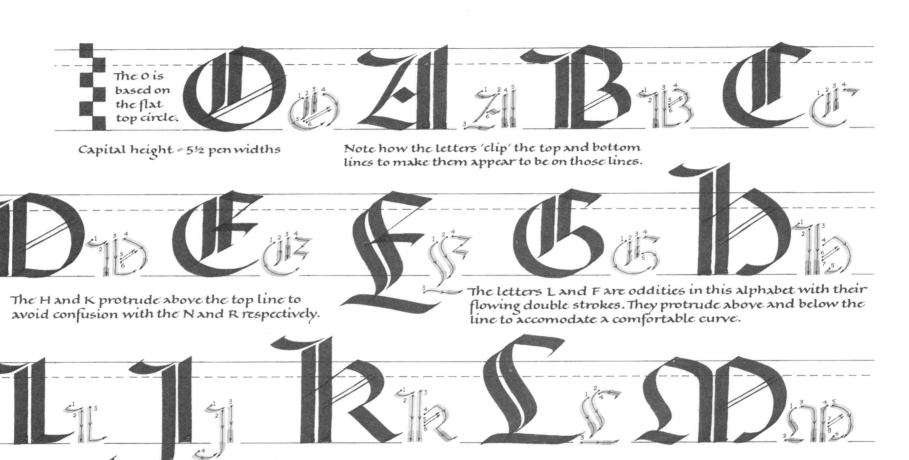

The O is based on the flat top circle.

Capital height = 5½ pen widths

Note how the letters 'clip' the top and bottom lines to make them appear to be on those lines.

The H and K protrude above the top line to avoid confusion with the N and R respectively.

The letters L and F are oddities in this alphabet with their flowing double strokes. They protrude above and below the line to accomodate a comfortable curve.

D P Q R

Try to make the white space between the
main strokes as even as possible.

S S T U

The thin diagonal lines are used to fill any
large area within a letter which would other-
wise show as too much white space, thus
destroying the rhythm.

W X Y Z

These capital letters are
based on a variety of
sources from Italian mss.
of the 13th, 14th and 15th
Centuries. A number of
early typefaces were also
based on the Rotunda

Pen angle about 35°.

was so.

xxxi And God saw every thing that he had made, and, behold, it was very good. And the evening and the morning were the sixth day.

II i Thus the heavens and the earth were finished, and all the host of them

ii And on the seventh day God ended his work which he had made; and he rested on the seventh day from all his work which he had made.

iii And God blessed the seventh day, and sanctified it: because that in it he had rested from all his

work which God created and made.

These are the generations of the heavens and of iv
the earth when they were created, in the day that
the Lord God made the earth and the heavens,

And every plant of the field before it was in the v
earth, and every herb of the field before it grew: for
the Lord God had not caused it to rain upon the
earth, and there was not a man to till the ground.

But there went up a mist from the earth, and wa- vi
tered the whole face of the ground.

And the Lord God formed man of the dust of the vii

The o is based
on an ellipse.

Notice how many of these letters
are executed in a single stroke.

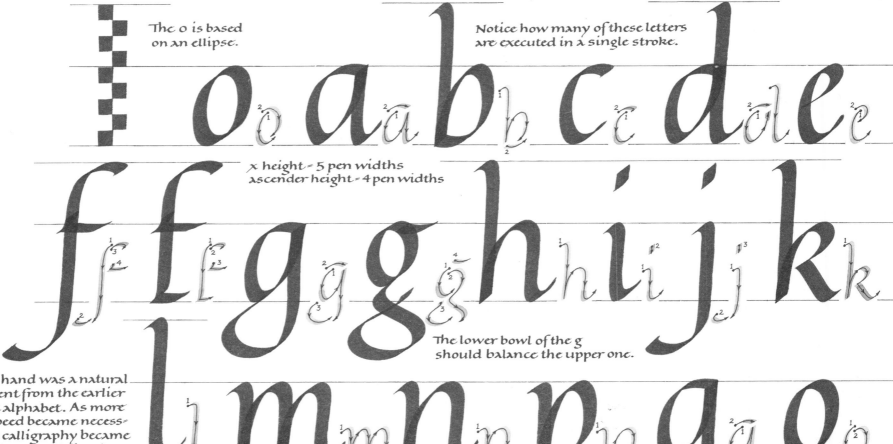

x height = 5 pen widths
ascender height = 4 pen widths

The lower bowl of the g
should balance the upper one.

The Italic hand was a natural
development from the earlier
humanist alphabet. As more
writing speed became necess-
ary, so the calligraphy became
less formal. For a while, the
Italic and humanist hands
were used concurrently, but
gradually Italic or cancellaresca
predominated.

r s t u v w x

This is the only one of the 'classical' hands which
has a definite lean; 5° or more from the vertical.

Note the 'spring' in the letters; an essential
characteristic of the Italic hand.

y y z 1 2 3 4

As with all the previous alphabets, there were no
arabic numerals used in Renaissance mss. These
were designed for use with this hand.

The up & down effect of the numerals
is traditional but not essential.

5 6 7 8 9 0

Pen angle about 45°.

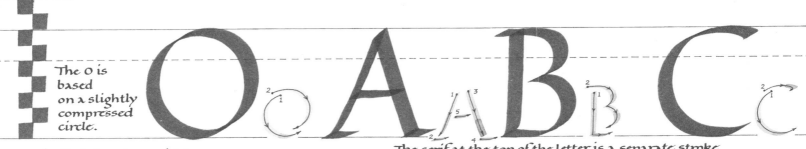

The O is based on a slightly compressed circle.

Capital height - 7 pen widths

The serif at the top of the letter is a separate stroke while that at the bottom is an integral part of the letter.

The separation between the two main strokes of the K relates to the open R. Do not over-exaggerate this space.

N P Q R

N N P P Q R R

Although, in the minuscule, the V and W are done in one stroke, the several strokes shown should be used here.

S T U V W

S S T T U U V V W W

The ampersand should probably be smaller when being used with minuscule letters.

X Y & Z

X X Y Y & & Z Z

In Renaissance mss. the capital letters used were slightly updated versions of the Roman quadrata. These capitals have been further updated by using a pen at a slightly flatter angle than that used in the minuscule. The proportions follow those of Roman inscriptional letters.

Pen angle 30° to 35°.

Flourishing is probably the most difficult of all aspects of the calligrapher's art to do well; and if it cannot be done well, it really should not be done at all. Nothing looks worse than an awkward swash.

ABCDEEFGHIJKLMNOPQRSTUVWXYZ

hojnknlsprato

Flourishes must only be done as natural extensions of the letter, so that, for instance, the letters C, O and S cannot be flourished at all.

aa bbccd deefgghh ijkklmm n pqrstu vwwlxyz

All swashes
should be
freely drawn
(except perhaps
when designing
them for graphic pur-
poses), and 'hot spots'
must be avoided (i.e. where too
many lines converge
in a small space.
Divide up space
equally.

ground, and breathed into his nostrils the breath of life: and man became a living soul.

viii And the Lord God planted a garden eastward in Eden; and there he put the man whom he had formed.

ix And out of the ground made the Lord God to grow every tree that is pleasant to the sight, and good for food; the tree of life also in the midst of the

garden, and the tree of knowledge of good & evil.

And a river went out of Eden to water the garden; x
and from thence it was parted, and became into
four heads.

The name of the first is Pison: that is it which com= xi
passeth the whole land of Havilah, where there
is gold.

And the gold of that land is good: xii

Improving Your Writing

If you began learning calligraphy straight from this book, by the time you have reached this point you will probably have found that very little, if anything, has gone exactly the way you intended. Your letters are likely to be somewhat shaky; they have little or no rhythm; they lack sharpness, and so on. Do not be discouraged. Everyone who has ever learned calligraphy has gone through this state in fact, if you look back at your very first attempts, you will be amazed at how much progress you have actually made. Your most significant findings will be that you can make a line with an almost infinite variety of thicknesses, simply by writing the first stroke of a letter *o* with a broad-edged pen. But, be warned. In the same way that a baby learns more in its first two years than in the whole of the rest of its life, your rate of progress from this point on will start to slow down.

A number of faults will have come to light, faults which every student of the lettering arts must contend with sooner or later. For instance: some of the letters may have a ragged edge on one side or the other. This is caused by one corner of the pen failing to make full contact with the paper while the letter is being written. Make sure that both corners are touching the paper throughout the whole length of the stroke and this will not happen. Some letters will lean in different directions from others. This fault will correct itself as you gain more experience and your eye becomes better trained. The pen angle varies from one part of the letter to another making for rather awkward shapes. This is more likely to occur when writing large. When writing small, the letters can be made by just moving the fingers, using the wrist as a pivot, and any variation in pen angle is so slight as to be unnoticeable. However, in large writing a change in pen angle may be as large as 20° to 25°. To write large it will be necessary to move your wrist and even, in some cases, your whole arm. The letters seem to have little strength: the straight strokes have too much "whip" in them. This can be corrected by practicing stick letters—just the basic skeletons without the lead-in or finishing strokes. Straight strokes in the skeletal letters dictate straight strokes in the corresponding calligraphic letter. Emphasis on the starting and finishing strokes should be kept to a minimum. If more is made of them than necessary, a minuscule *l*, for instance, can take on the look of mirror image *s*, or a butcher's hook.

The left hand corner of the pen has been lifted from the paper surface, causing the ragged edges.

The angles of the letters are all different. A piece of paper with ruled vertical lines may be tucked under the writing sheet as a beginner's guide.

The angle of the pen varies as the diagonal lines show. Move the whole hand through the letter rather than just the fingers.

will

These letters have too much "whip" in them. Keep the basic skeletal shapes in mind while writing.

room

These letters have no definition. Make sure that all letters relate to each other in any given alphabet.

minimum
minimum
minimum

These three words were all written with the same sized pen. Note that, just because the × height is larger as in the italic version, it does not mean that the letters occupy more linear space. The longest word is that written in the Foundational hand because of the width of the counter.

The last fault common in beginners' work is that the basic shapes are not definitive. If, for instance, you are writing a Foundational hand, the *o* should be based on a circle and not some indeterminate shape which approximates a circle, and all of the other letters should relate to that. The same is true of the Italic hand. The *o* has a definite elliptical character; that shape should permeate the whole of that alphabet.

These are just a few of the more obvious faults. Others may show up in the course of time, but by careful observation of the letter shapes in this book and other manuals, as well as by analysis of historical examples, you should be able to correct these faults by yourself.

After all that, it is time to turn to the more fundamental aspects of calligraphy. There are three basic principles governing the successful execution of a calligraphic piece, apart from the design which we will cover briefly at a later stage. In order of importance, these are: rhythm and spacing, sharpness, and spontaneity.

When we talk about rhythm in writing, we mean the same as the musician means by rhythm—an evenness of beat, both in execution and in appearance. In calligraphy it means regularity of the downstroke. It does not mean, that if all of the downstrokes were to be measured with a rule, they would be exactly the same distance apart, but rather, that when the whole piece is viewed, a definite measured tread can be seen.

To establish that pattern, the space inside the letter (called the counter) must first be analyzed. Once this is done, try to leave approximately the same amount of space between the letters (the interspace.) To begin with, it may be necessary to make a conscious effort to do this, but with experience it will become automatic and natural. In a minuscule hand the largest amount of interspace is to be found following the letter *r*. This space may be lessened by either shortening the bar of the *r*, or by tucking part of the ensuing letter under the *r* thus closing up the space a little. A combination of the two approaches may also be used.

When writing a piece all in capitals there are other pitfalls to watch out for. The two worst juxtapositions of capital letters are an *L* followed by an *A*, and two *T*s one after the other. In these cases, the horizontal strokes may be shortened slightly, the letters may even be joined, but normally, it will be necessary to space out the rest of the letters to compensate for the areas between these two sets of characters. Practice and experience will determine which is the best solution in a given case.

Sharpness in writing is simply the contrast between thick and

thin strokes and the ability to achieve hairlines. Lack of sharpness is a relatively easy fault to correct, because it is usually a matter of technique rather than eye. It is unfortunate that all pen sizes from each manufacturer are made from the same thickness of steel. It would be better, for example, if William Mitchell Round Hand pens sizes 00, 0, 1 and 1½ were made from one thickness, 2, 2½, 3 and 3½ were made from a slightly thinner gauge and the balance from a still thinner steel. As it is, the 00 is made from the same gauge steel as the 5 and while the contrast between the thicks and thins is fine with a 00 pen, it is poor with the 5. This problem can be mainly overcome by the simple expedient of sharpening the smaller sized pens. Using a soft Arkansas stone or a fine grade oil stone (do not use oil on them, it will make the pens very difficult to use; a little spittle will work fine), gently hone down the top edge of the blade of the pen at a cross section angle of about 30 degrees. Make sure that the edge of the pen is sitting flat on the stone for it must be evenly ground. Keep working the pen until you have reached the point where a good contrast between thick and thin strokes can be achieved.

If your writing is still not as sharp as you would like, you should look to the ink that you are using. Pigmented inks do have a tendency to thicken up after they have been open for a while. They can be thinned down by adding a little distilled water. Add it a drop at a time and test it to make sure that the ink does not become too dilute or gray. Remember to load the pen with a brush, rather than dipping it into a bottle, and be sure not to overload the pen.

Spontaneity and freedom are admirable qualities in the hands of the experienced calligrapher, but unless properly understood they can be fatal to the beginner. True, the art of calligraphy depends a great deal upon the freshness and dash of the freely written letter, but its real beauty comes from good strong letter forms. Often, weak and wishy-washy letters are concealed behind the cloak of freedom. It is essential to learn the basics before going on to the more expressive forms of the art. To take an analogy from music, the alphabet is to the calligrapher what the scale is to a musician. What serious-minded musician would consider playing Beethoven's *Moonlight* Sonata before he had learned to play the scale of C major. Complete familiarity with the various written hands will, in the end, breed its own spontaneity.

To acquire a good text hand, the mark of the true calligrapher, one must absorb these basics completely. Arriving at that text hand has been likened to coming up against a brick wall and a real jump is necessary to clear it. Some never make

ro
ro

Normal *r*, regularly spaced from the *o*; Shortened bar on the *r*, with the *o* tucked in slightly, so as not to interfere with the rhythm.

LATTER
LATTER

Two words showing, first, the poor spacing which occurs if *LA* and *TT* are of normal shape and regularly spaced. This destroys the rhythm and makes it difficult to read.
The second example shows how the rhythm has been improved by shortening the bars of the *T*s, squeezing the *A* slightly, and closing up.

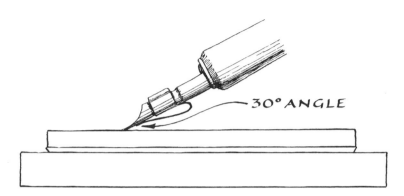

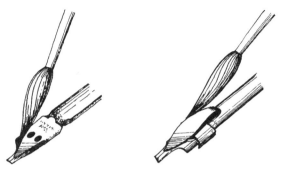

To sharpen the pen, hold it at approximately 30° and move it gently backwards and forwards along the stone. Always keep the pen sitting squarely on the stone.

(*left*) Using a brush, load the underside mounted reservoir at one side of its tip. (*right*) Using a brush, load the ink into the top mounted reservoir from the side;

it, others do, but that leap can come at the most unexpected place and time, often right in the middle of a piece of work. Once over that wall writing a page of text will become almost as automatic as breathing. The pen will be a natural extension of your arm. No longer will it be necessary to think about whether the next letter will fit with the previous one—it will happen whether you will it or not. You will have become a calligrapher.

For all of that, however, a note of caution must be sounded. The art of calligraphy requires constant practice. It is not something which can be put down and picked up like the skills involved in riding a bicycle. Instead, like playing a musical instrument, time must be spent on a regular basis. Once acquired, these skills must be constantly honed.

Layout, Design, and Color

Concerning layout, one must first of all consider the uses to which calligraphy was put in the Middle Ages and the Renaissance. In those periods, with the exception of certain legal and administrative documents, calligraphy was used almost exclusively in the making of books. It stands to reason, therefore, that the layout of formal calligraphic work should be greatly influenced by the design of the medieval manuscript book.

In 1953, Jan Tschichold, the great Swiss typographer, rediscovered the Golden Canon of the late Gothic era governing the layout of books with the proportion ratio of 2:3. This canon states that the height of the text is equal to the width of the page. There were other proportions in use at the time but this seems to have been the most widely applied. Tschichold says in an essay, "Non-Arbitrary Proportions of Page and Type Area" in *Calligraphy and Palaeography* edited by A. S. Osley, that the only page proportions which are truly pleasing are those which are geometrically well defined and not arbitrary.

These he divides into two groups: the rational and the irrational. On the rational side he lists page proportions of 1:2, 2:3, 3:4, 5:8 and 5:9; while on the irrational side are: 1:1.618 which is the mathematical rendering of the Golden Mean, 1:$\sqrt{2}$, 1:$\sqrt{3}$, 1:$\sqrt{5}$ and 1:1.538 which is the rectangle from the pentagon.

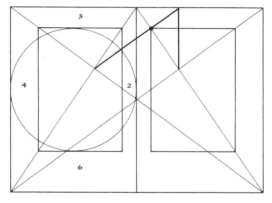

This diagram shows the secret canon rediscovered by Jan Tschichold in 1953. The page proportion (not the sheet of paper) is 2:3 as is also the text area. The thin diagonals are drawn first, and then, those lines shown heaviest are drawn to divide the page into ninths. The circle has been drawn in to show that the height of the text area equals the page width. The dot, in each case, indicates the starting off point for drawing the margins.

Thanks to Tschichold's researches we are now able to establish margins which are pleasing because the text area is in direct proportion to the page. Returning to the 2:3 page, the ideal margins are as follows: the inner margin is one ninth of the width of the page (that is, one ninth of half of the long side of the sheet of paper), the outer margin is two ninths. Similarly, the top margin is one ninth of the height of the page, and the bottom margin, two ninths. This converts to margin relationships of 2:3:4:6. Fortunately, it is unnecessary to do all of these divisions with a ruler and calculator. They may be worked out much more simply with geometry, as shown. The same geometrical approach may be used on pages of other proportions to arrive at the same attractive margins. Different page sizes will give slightly varied margin ratios, but the principle remains the same.

Though this information relates directly to the book page, the principle also holds good for use in a single page, or broadside, layout. The sheet of paper should be divided in half as if for a book and the diagonals drawn in the same fashion. When that has been done, the margins at the center of the double page spread can simply be ignored.

In the case of a broadside where the lines of writing would be too long to be easily read, the test should be divided up into a series of two or more columns. The number of columns will be dependent upon the size of pen used. A single line of writing

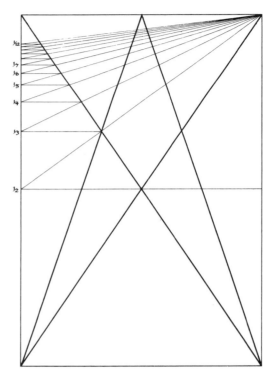

This diagram shows a method using geometry of dividing a page into as many as twelve equal sections.

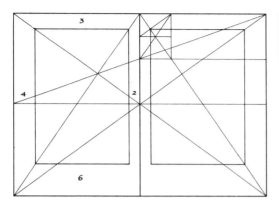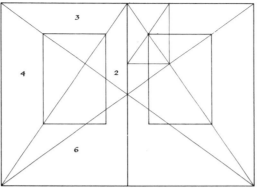

Although margins are classically established as multiples of ninths of the height of the page, other divisions may be used. The left diagram shows margins worked from one twelfth of the page height, and the right, margins from the sixth.

should not contain more than twelve words, nor less than five, and the optimum is eight or nine.

Once the text area is determined it is necessary to find out which pen size should be used, and to do that, we first have to count the number of words to be inscribed. To begin with, count the number of words in each of several lines of the text and take the average. Multiply that by the number of lines to arrive at an approximation of the total number of words. Next, write out one line of the text to the full width of one of the columns or text area if columns are not being used. Dividing the number of words written into the total number of words in the piece will give you the total of lines writing with that size of pen. If there are too few lines to fill the space with comfort use

a larger pen; conversely, if there are too many lines, use a smaller pen.

Once the text layout has been determined, it will be necessary to consider the overall design. A full page of nothing but writing of all one size will be monotonous. There are a variety of ways in which this can be overcome; contrasts in writing sizes, styles and weights, illustrations and decoration, and any number of colors may all be used to add visual excitement.

While a book page, even with the occasional decorative initial or illustration, will be a fairly simple and easily read object, a single sheet which will be framed and placed on a wall may be as varied and exciting as the artist can make it. Nor

Using the same principles and disregarding the center margins, we can design a broadside, and divide the text area into as many columns as necessary.

does the work have to be produced in only the usual materials such as paper and vellum. More and more calligraphic artists are now using the media traditionally reserved for the fine artist. A number of calligraphers are working on canvas and silk, as well as other materials, using acrylics and dyes. Calligraphic design, as in all facets of the graphic arts, can range from the most simple thing such as an invitation or a menu, to the most complex works which can more accurately be described as calligraphic paintings.

It is difficult, in an introductory work, to give a complete

design course, but a few pointers can be offered as stepping stones to more complicated procedures. Earlier in this section mention was made of the Golden Mean (sometimes known as the Golden Rule.) This is a proportional ratio of 21:34 (1:1.618). No one knows why this particular proportion is so pleasing to the human eye, but it is. If one studies the works of the old masters, one can see that areas of those paintings have been divided into these proportions time and again. That is not to say that those masters consciously arranged the structure of their canvases to fit the proportions of the Golden Mean, but that they were subconsciously aware that a well composed picture called for the divisions dictated by it.

As calligraphers, we can learn a great deal for earlier artists. By applying the Golden Mean, we can divide a page in such a way that one part has greater importance than the other. If a page is simply halved, neither side had emphasis and the result is usually confusing and boring. Bearing this in mind, try taking a piece of white paper and a smaller rectangle of black paper, and play around, laying the black paper in different positions on the white. Imagine that the black rectangle represents a piece of text which can be moved around at will until a pleasant composition is achieved. Take another even smaller piece of paper of a different color and move that around until, in conjunction, the two parts make an even more interesting arrangement. These two pieces may even be cut up smaller to

These pages are divided exactly in half. The eye is bored and confused because neither side has prominence.

When pages are divided on the Golden Mean (21:34) the eye focuses on one part of the composition.

make more exciting patterns. Remember, that in any piece of design, the areas of white are just as much a part of the work as the colored areas. Now, instead of using bits of paper, try using pieces of writing of differing weights and colors, until a design is arrived at that seems to solve the problem. You will notice that when writing is substituted for the pieces of paper, the tonal value will be considerably reduced and this must be allowed for.

This is the basic principle of two dimensional design—the division of large white areas into smaller ones by use of blocks

and lines of different colors. The white space must always be considered to be as important as the dark, just as the counter of a letter is as important as the dark mark which encloses it.

The student of calligraphy is urged to look at all forms of design which can be seen around us, whether it be graphic or fabric design, architecture, fine art or industrial design. All have bearing on our artistic sensibilities. Be excited by what you see around you and that excitement will come to be reflected in your work.

The use of color is highly personal and subjective. Histor-

a. A piece of black paper of the same proportions as the larger white sheet is laid in the center. It has little visual impact.
b. The black paper is moved up and to the right so that its left-hand edge butts up against what would be the Golden Mean.
c. The black sheet is cut into four equal pieces which are then moved slightly away from each other.
d. The bottom left piece is moved down and to the left so that its right hand edge lines up on the Golden Mean.

ically, the role of color in manuscripts was very limited. In most Gothic manuscripts, for example, color was confined to red and blue (occasionally green) and that generally only on initial letters. All of the other colors were reserved solely for the decoration and miniatures. Today color is used quite freely particularly in writing.

e. A small strip of red paper is laid in to indicate a headline.
f. Writing is laid in to substitute for the black and red papers. Some things should be noted. The graphic impact is reduced because of the white areas between the lines of writing. A heavier weight of writing is used at the bottom left to create greater variety. The introduction of color does not necessarily mean that that piece of color has the greater impact.

This is not the place to discuss color theory—that would require a whole book of its own and, in any case, you will be able to decide for yourself which color arrangements please you. What can be discussed, though, are the various media which are suitable for our purposes. Gouache (designers' colors) and artists' water colors are the two media most favored by calligraphers. The bottled watercolors and colored inks are not recommended. The first contain dyes which are not light fast and the second are waterproof and will clog the pen, as well as being translucent.

When mixing gouache for writing, simply add water until the resulting mixture is just thin enough to flow easily through the pen. With watercolors, it may be necessary to add a little white to the blues and greens for they have less body than other pigments and will look a little thin on the paper. It is advisable to stay away from the earth colors like the ochres, umbers, and siennas because they do not flow very well. However, it is possible to mix something close to them from other colors. The drawing board should be placed flat when writing with color as the pigments have a tendency to settle to the bottom of the letter when the board is at the usual angle.

With layout, design, and color, we are all influenced both by what has gone before and by what we see around us. Be observant and learn to absorb visual information. If you see an idea you like adapt it to your own use. There are, after all, few new ideas in the graphic arts, only the revamping of old ones. Similarly in calligraphy—there are now new letters, just different approaches to their styling. It is probably safe to say that basic letter shapes will not change much at all in the next few millennia.

Conclusion

Since the advent of printing, calligraphy has never been in a healthier state than it is today. Interest in the art has continued to grow since its rebirth at the beginning of this century. Its study and understanding is more widespread and more profound than at any time in its history.

We are fortunate that there are many calligraphic societies throughout the United States and the rest of the world, offering workshops to their members, many of them taught by some of the best known calligraphers. The serious student is urged to seek out and join one or more of these associations. However good a teaching manual may be, it can never be as satisfactory as the direct teaching of an expert. Much can be learned just from watching an expert calligrapher make a letter, apart from the obvious advantage of being in a class with others, and gaining from the free exchange of information. Questions often crop up which just may not occur to everyone, and by hearing the answer one can gain further insight into the craft. A number of the societies also produce excellent newsletters which keep members abreast of what is happening in the field.

It can reasonably be hoped that interest in calligraphy will continue to grow and, at the same time, find new avenues of expression while remaining true to the ideals of strong and beautiful letter forms. Let us also hope that in the very near future, calligraphy will come to be accepted by all as a bright and exciting art form.

Bibliography

Anderson, Donald. *The Art of Written Forms: The Theory and Practice of Calligraphy*. New York: Holt, Rinehart & Winston, Inc., 1969.

Backhouse, Janet. *The Lindisfarne Gospels*. Ithaca: Cornell University Press, 1981.

Brown, Peter. *The Book of Kells. A Selection from the Irish Medieval Manuscript*. New York: Alfred A. Knopf, Inc., 1980.

Camp Ann. *Pen Lettering*. New York: Taplinger Publishing Co. Inc., 1958.

Child, Heather, ed. *The Calligrapher's Handbook*. New York: Taplinger Publishing Co., Inc., 1986.

Child, Heather. *Calligraphy Today*. New York: Taplinger Publishing Co., Inc., A Pentalic Book, 1976.

Harvard, Stephen. *An Italic Copybook: The Cataneo Manuscript*. New York: Taplinger Publishing Co. Inc., 1981.

Jackson, Donald. *The Story of Writing*. New York: Taplinger Publishing Co., Inc./The Parker Pen Co., 1981.

Johnston, Edward. *Writing and Illuminating and Lettering*. New York: Taplinger Publishing Co., Inc., 1977.

Morison, Stanley. *Politics and Script: Aspects of Authority and Freedom in the Development of Graeco-Latin Script from the Sixth Century B.C. to the Twentieth Century A.D.* Charlottesville: University of Virginia Press, 1972.

Ogg, Oscar. *Three Classics of Italian Calligraphy: The Writing Books of Arrighi, Tagliente, Palatino*. New York: Peter Smith Publications, Inc., 1953.

Osley, A. E., ed. *Calligraphy and Paleography: Essays Presented to Alfred Fairbank on his Seventieth Birthday*. London: Faber and Faber, Ltd., 1965.

The Society of Scribes and Illuminators in conjunction with the Taplinger Publishing Co., Inc. *Contemporary Calligraphy: Modern Scribes and Lettering Artists II*. New York: Taplinger Publishing Co. Inc., 1986.

Whalley, Joyce Irene. *The Pen's Excellencie*. New York: Taplinger Publishing Co., Inc., 1982.